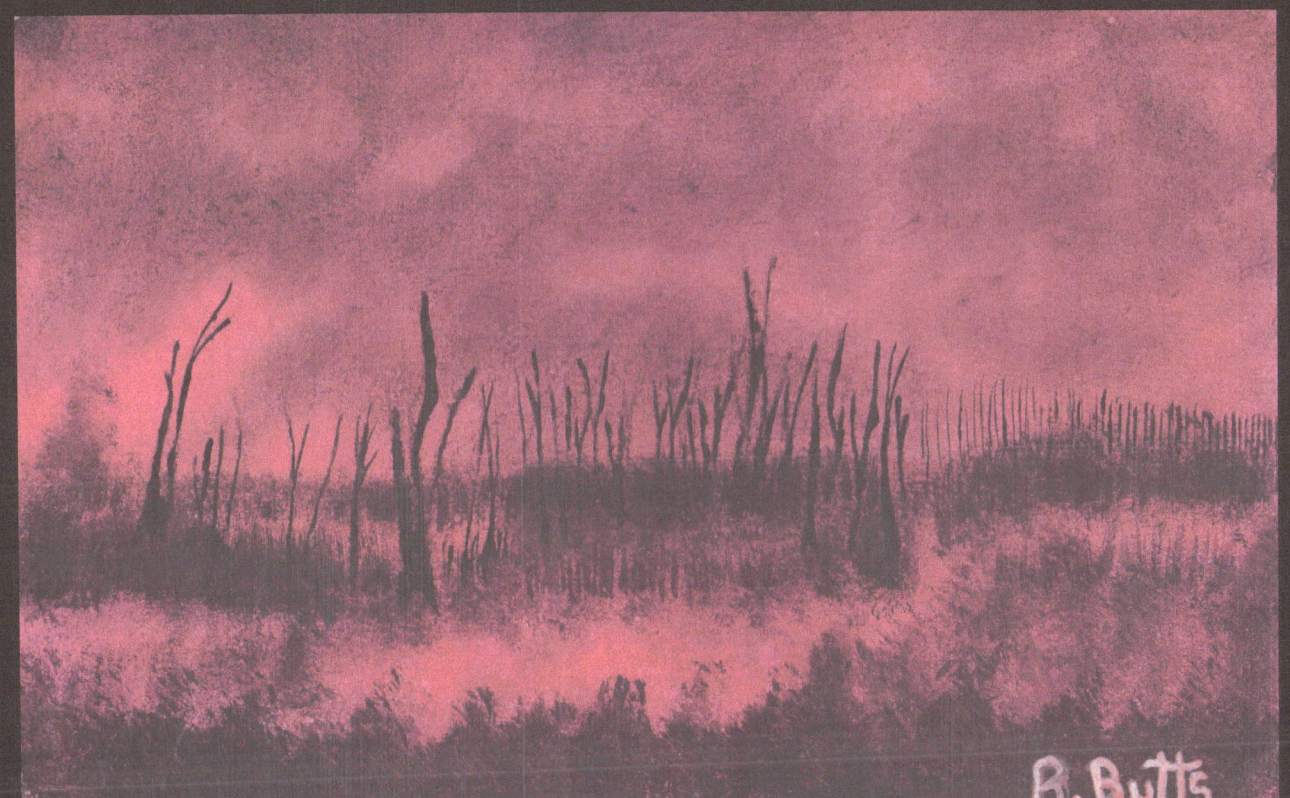

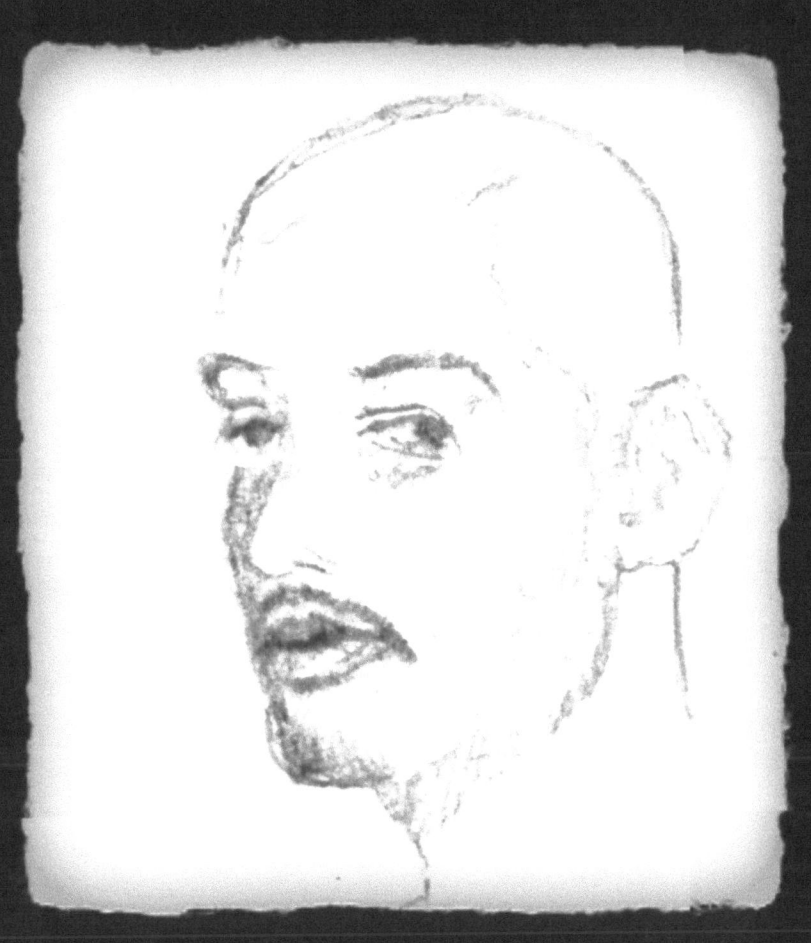

for my grandmother

a portrait of my journey

Memoirs from Death Row

Robert E. Butts

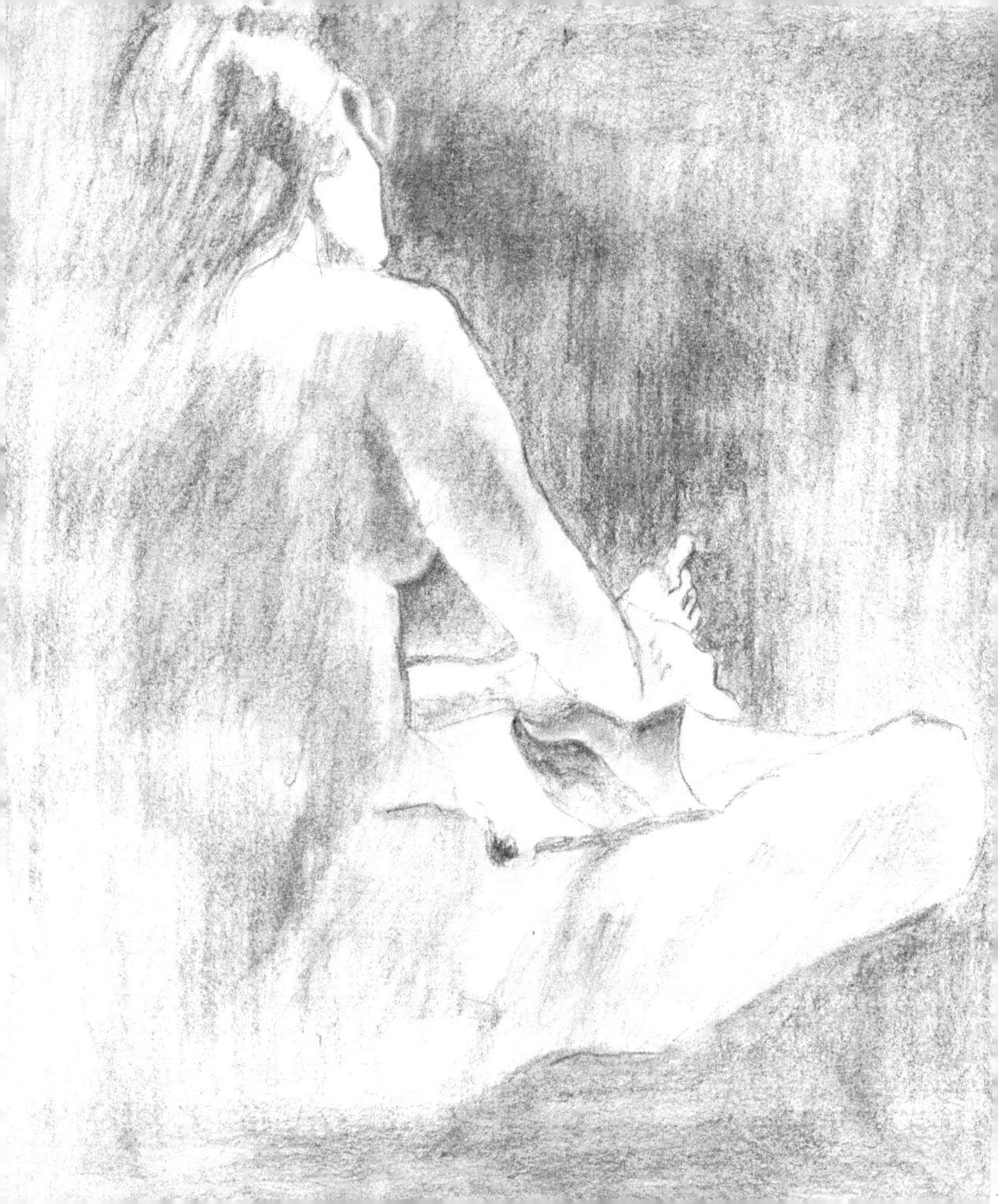

Tomorrow

You are only a day away,
my dreams you hold in store…
No guarantee what tomorrow will bring,
there's endless possibilities to explore…

Anxiously I await your arrival,
thus I am not a patient man…
You have me in a state of uncertainty,
and this I cannot stand…

I plan for you today,
doing all in my power…
Hoping for your mercy,
the love which you can shower…

I feel that I saw your shadow,
it had to be an illusion…
My mind is in disorder,
A serious state of confusion…

Never will I stop seeking you,
From this I will never sway…
I know that we will meet eventually,
That tomorrow will come one day…

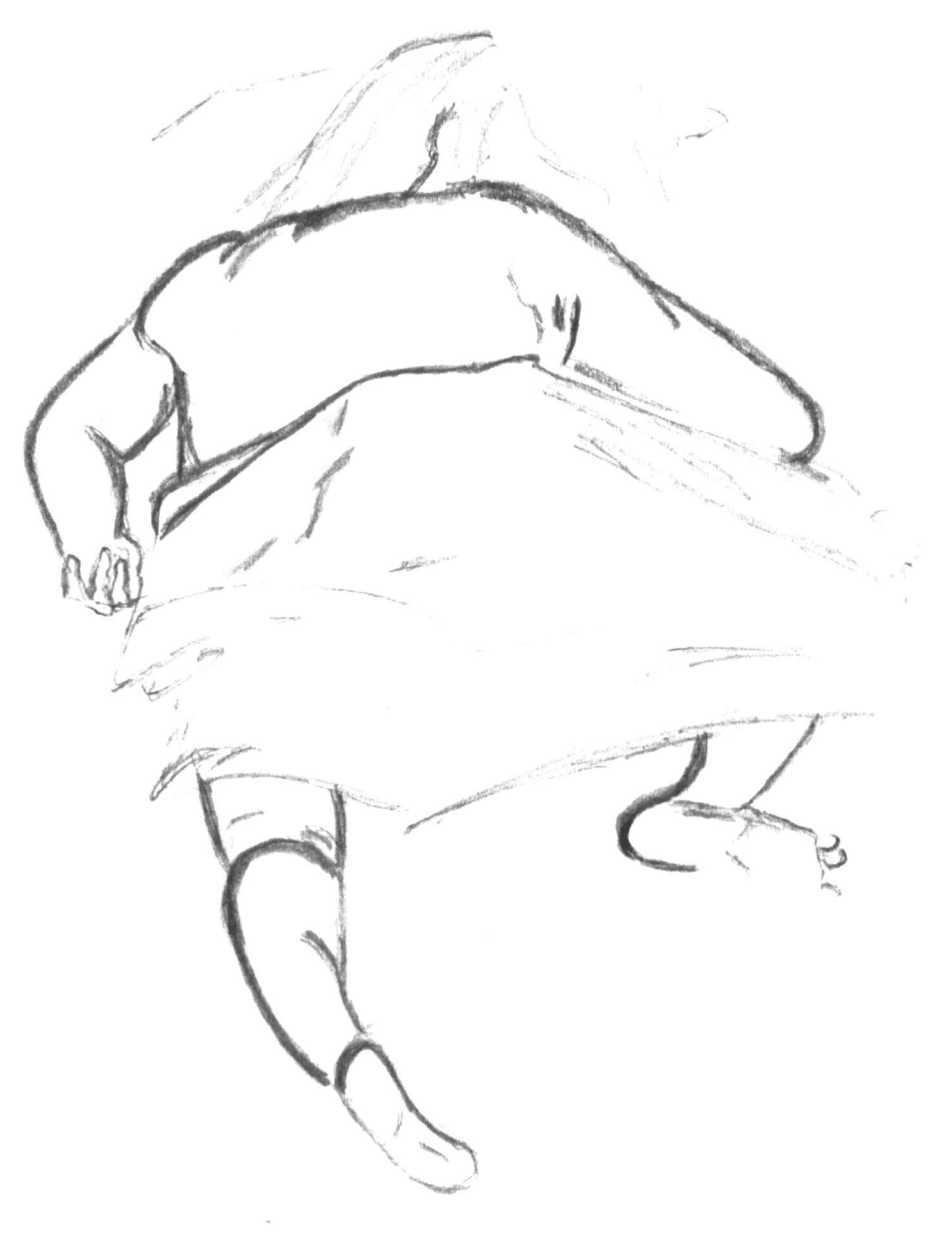

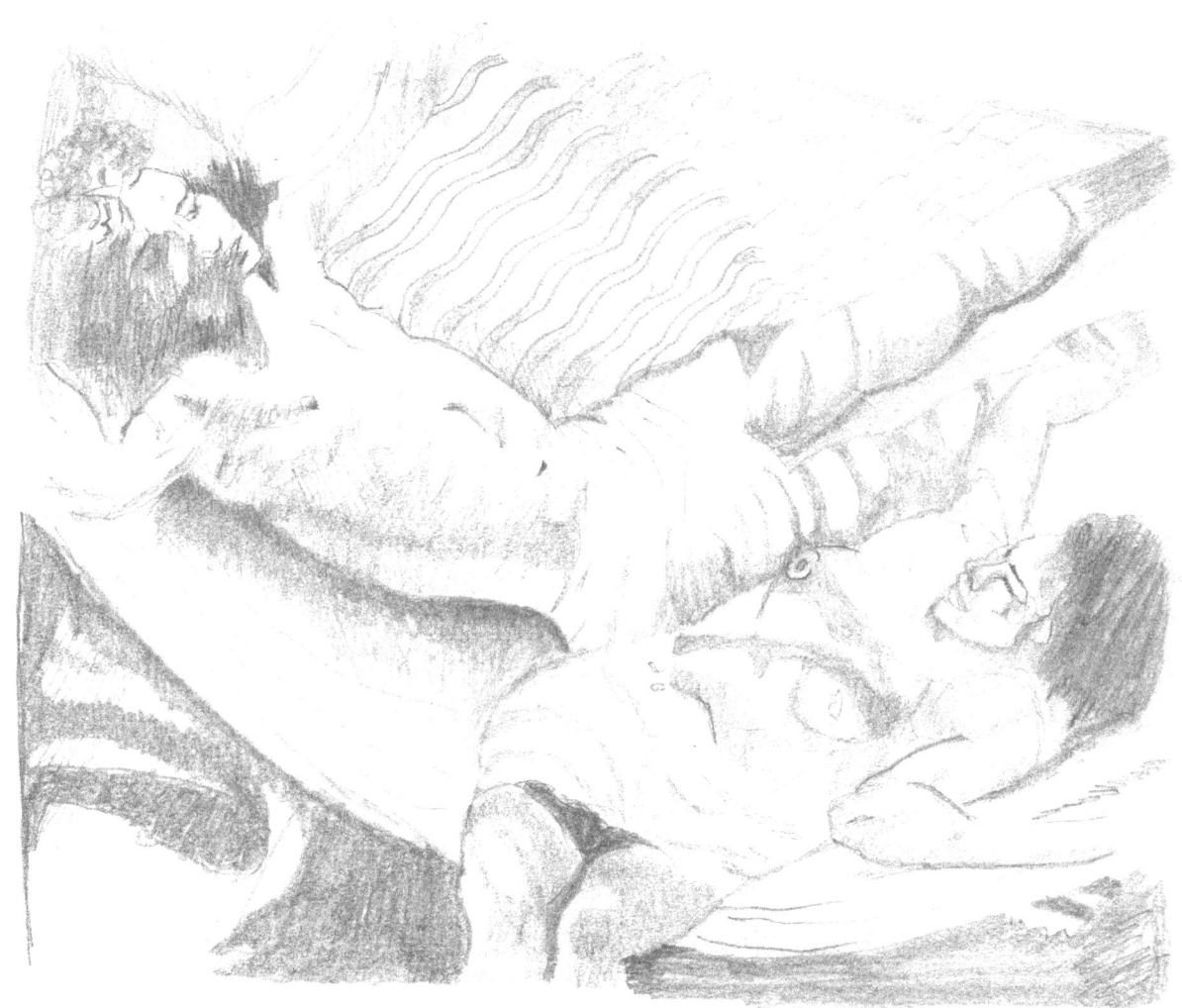

12/10/07
Robert Butts

There Are Two Within Me

There are two within me,
I can see this clearly now -
but who are they
and how do I contact them?
I would like to
convey my message
to each one
and show
that my approach
is sincere
and how I long
to be near
what so many of us fear...

Hello
are you listening to me?
Do you want to know me also,
or are you
just as afraid and scared
as I am?
I think we should both
take a step forward
and see what we
both have to offer.

What do you think?

The Formula

Now and Then

You feel certain wayz

As minutes turn to hours

and hours turn to dayz.

One can't always control how they feel

but if composure is kept,

then you can always build.

You must cultivate the moment

into a meaningful interval

not to become mundane

but yet integral.

Alwayz stay agile

and remember to be grand.

Move freely like the wind

but keep your feet on the land.

Now and Then...

You must avoid temptation.

Stand your ground

and deface the situation.

Even when you've been pushed to the edge

Keep surging forward

and eventually you'll get ahead.

Just be patient,

because life isn't fair...

Have faith in yourself,

and believe you'll make it there!

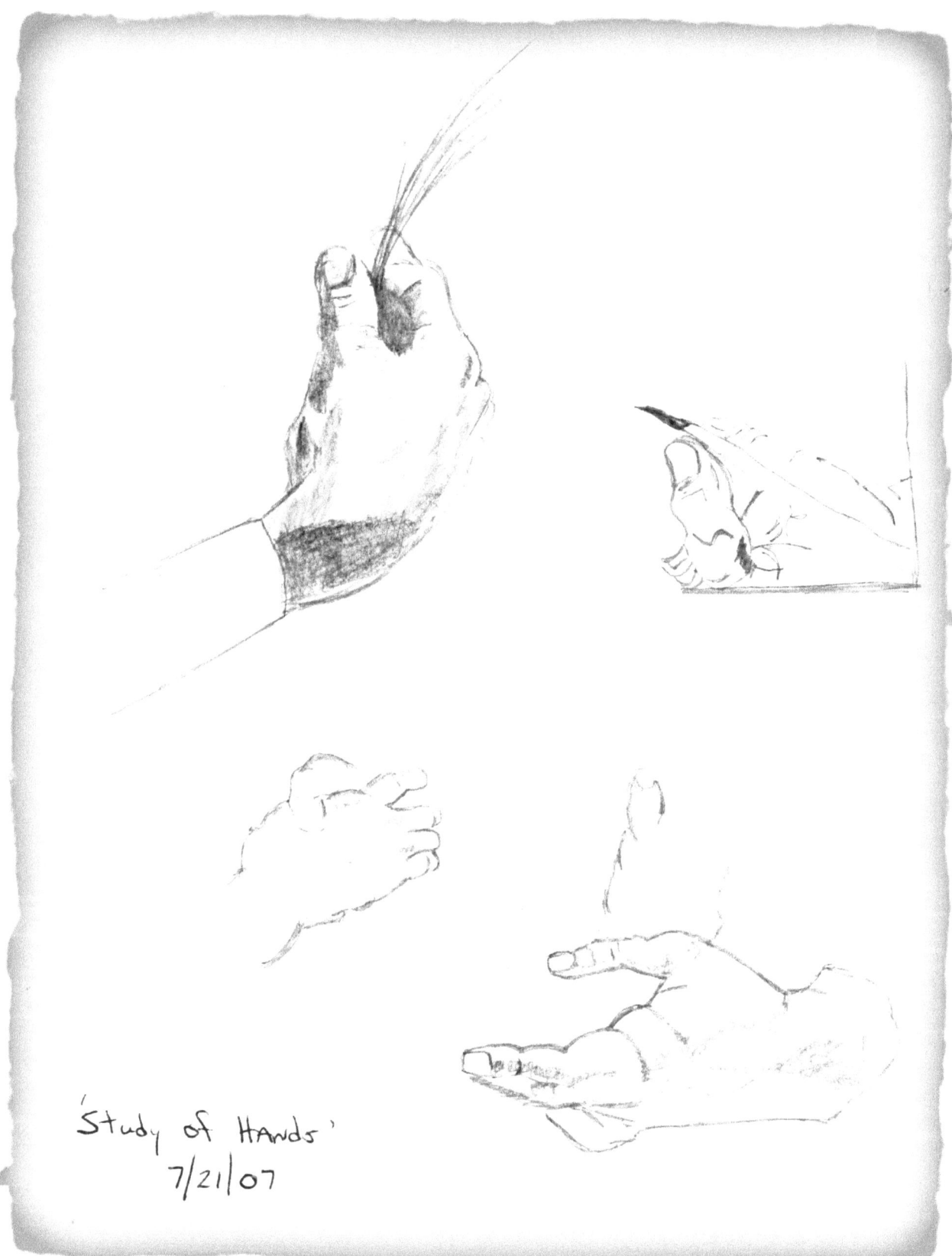

Brief Bio, January 13th, 08

On May 14th, 1977, I was born in the small city of Milledgeville, Georgia, just as exuberant as any kid might be upon entering this world, but I entered a life which contained very little hope.... And without any understanding or comprehension of what was going on around me, I eventually gave in to all that was surrounding me at the time...

Arrested during the 18th year of my life, I now sit on Georgia's death row, some 12 years later, full of hope while understanding and comprehending the path that has led me to this point...

I became a student of Art in 2004 with the assistance of some "how to" books and the help of my friend, Joshua Bishop, who is also from Milledgeville and resides on death row only a few cells away....

The world of Art and the people in it has helped to bring meaning to a life that lacked purpose.... One thing I've learned is that life is full of transitions and adjustments; and how a person handles these situations will leave a remarkable footprint in this lifetime...

It took all that I went through for me to become the man that I am today... A person who handles transition well and makes adjustments accordingly, and in doing so, the world of Art has stamped my life with it's own unique footprint that's visible to all, if only you can see beyond the contour shapes into the exquisite patterns of life itself... Robert Butts

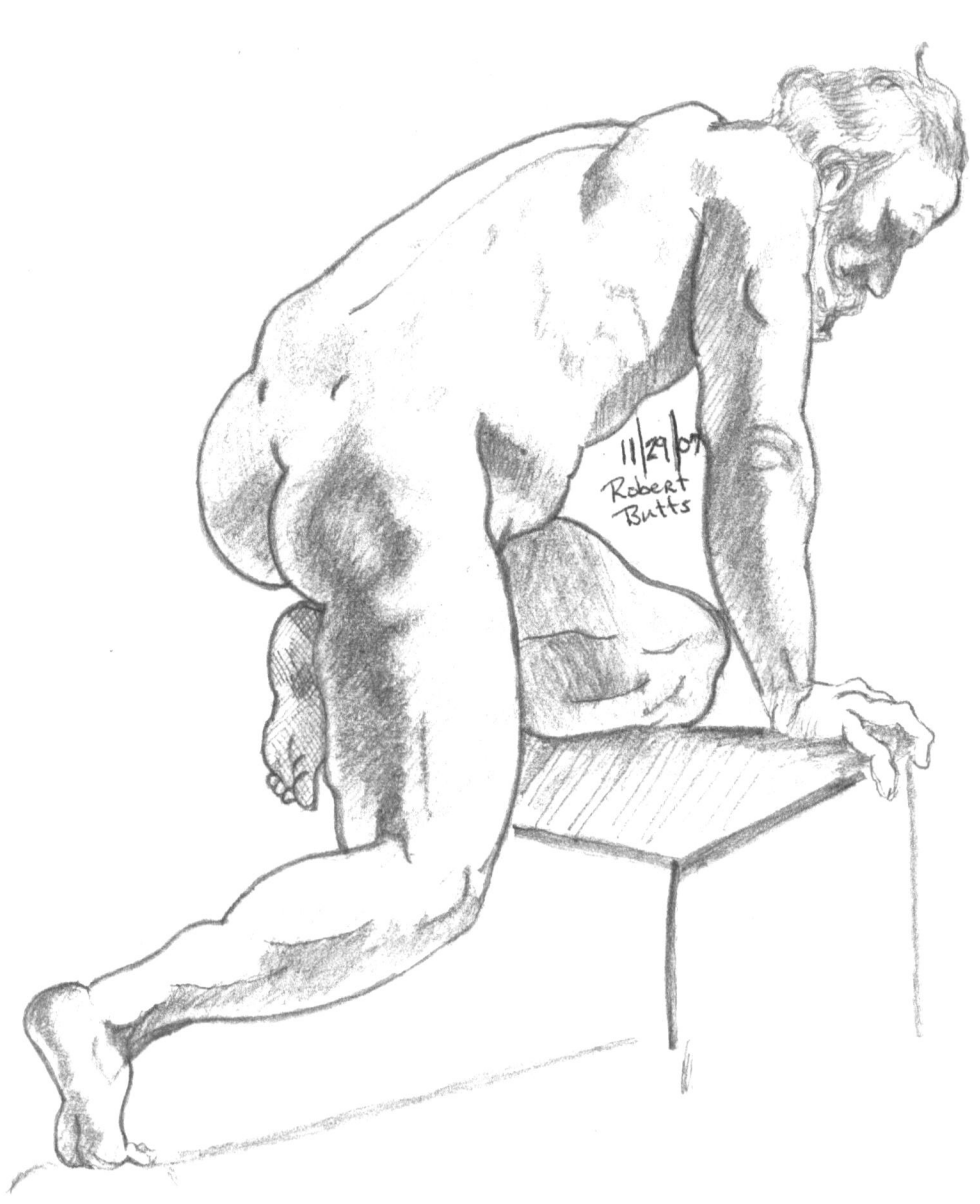

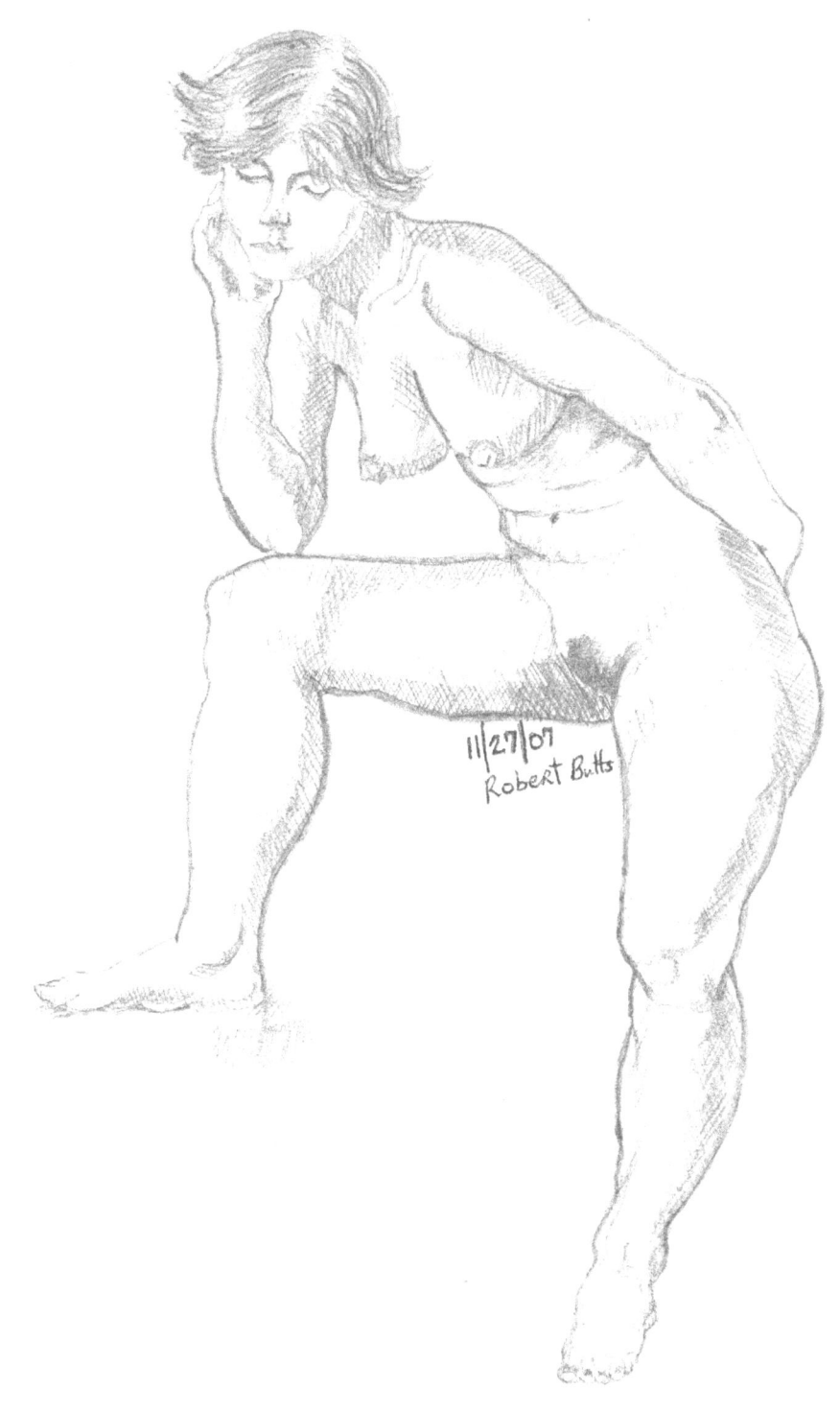

HONESTY

Honesty has great worth,
it can be a driving force...
And if you are a noble person
then this will be the source...

Honesty has significance,
it is usually taken lightly...
And when it is revered decently,
relationships will be wrapped tightly...

Honesty is a gift,
in which most have not received...
These people have yet to learn,
even they lose when they deceive...

Honesty can be difficult,
and very rarely possessed...
You would know what I mean,
if you're ever put to the test...

Some people are indeed honest,
we are scattered here and there...
We are bound by our earthly duty,
to infect people everywhere...

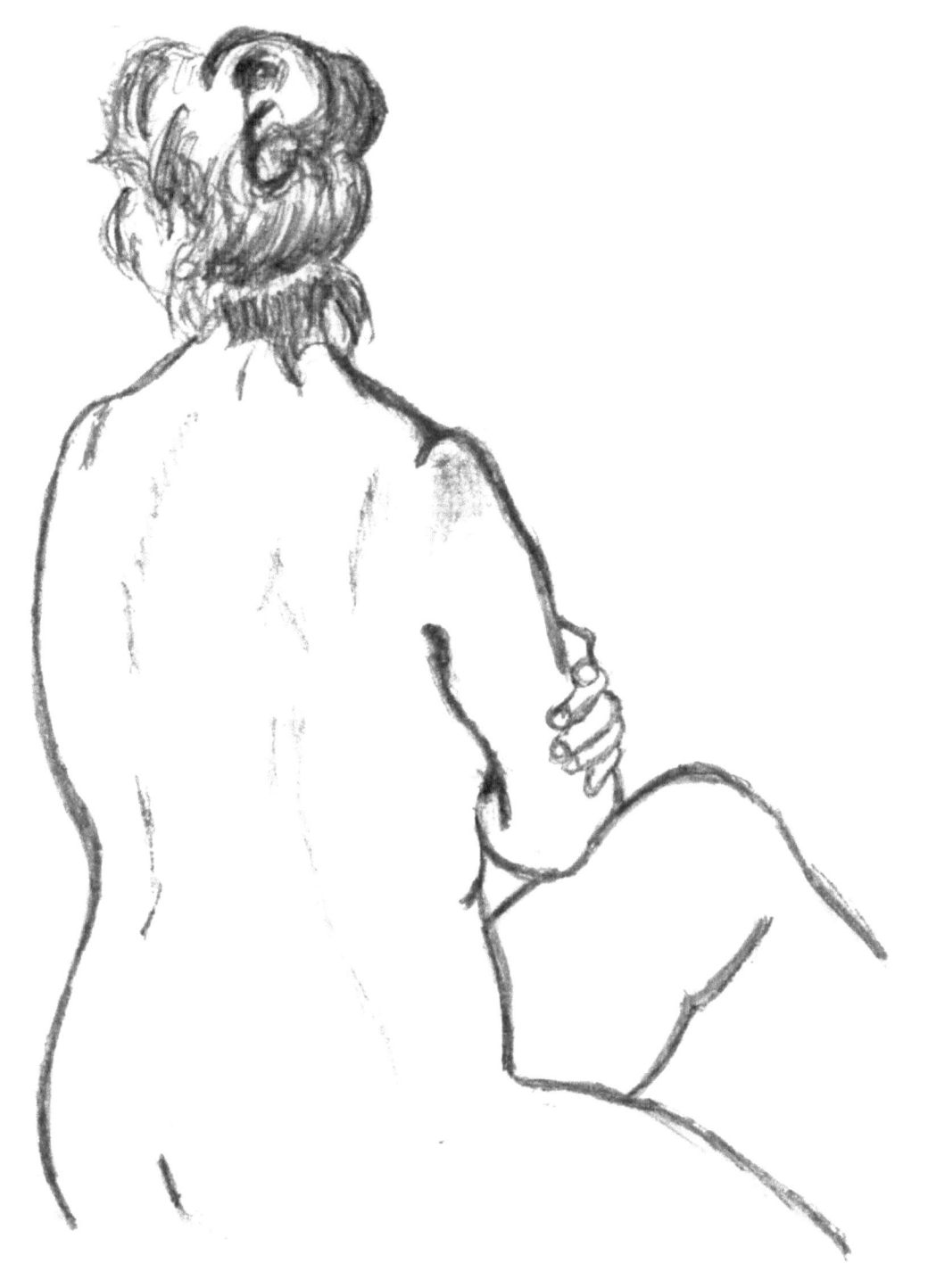

My Life

Part I

Living in the land of the lost,
Waking to the sound of bells…
Like making a long strenuous journey,
With your mind being trapped in hell…

Living amongst sanctions
Which are meant to weaken your soul…
Like living an incomplete life
With no chance of fulfilling the holes

Living life as a number
Thus destroying your credentials
Equivalent to living a failed life
That was so full of potential

Living a life full of regrets
Certainly that which I endure
Like being infected with a mortal disease
For which there is no cure

Living a life absent of light
Like being trapped in an abyss
And making it out of this place alive
Remains my biggest wish

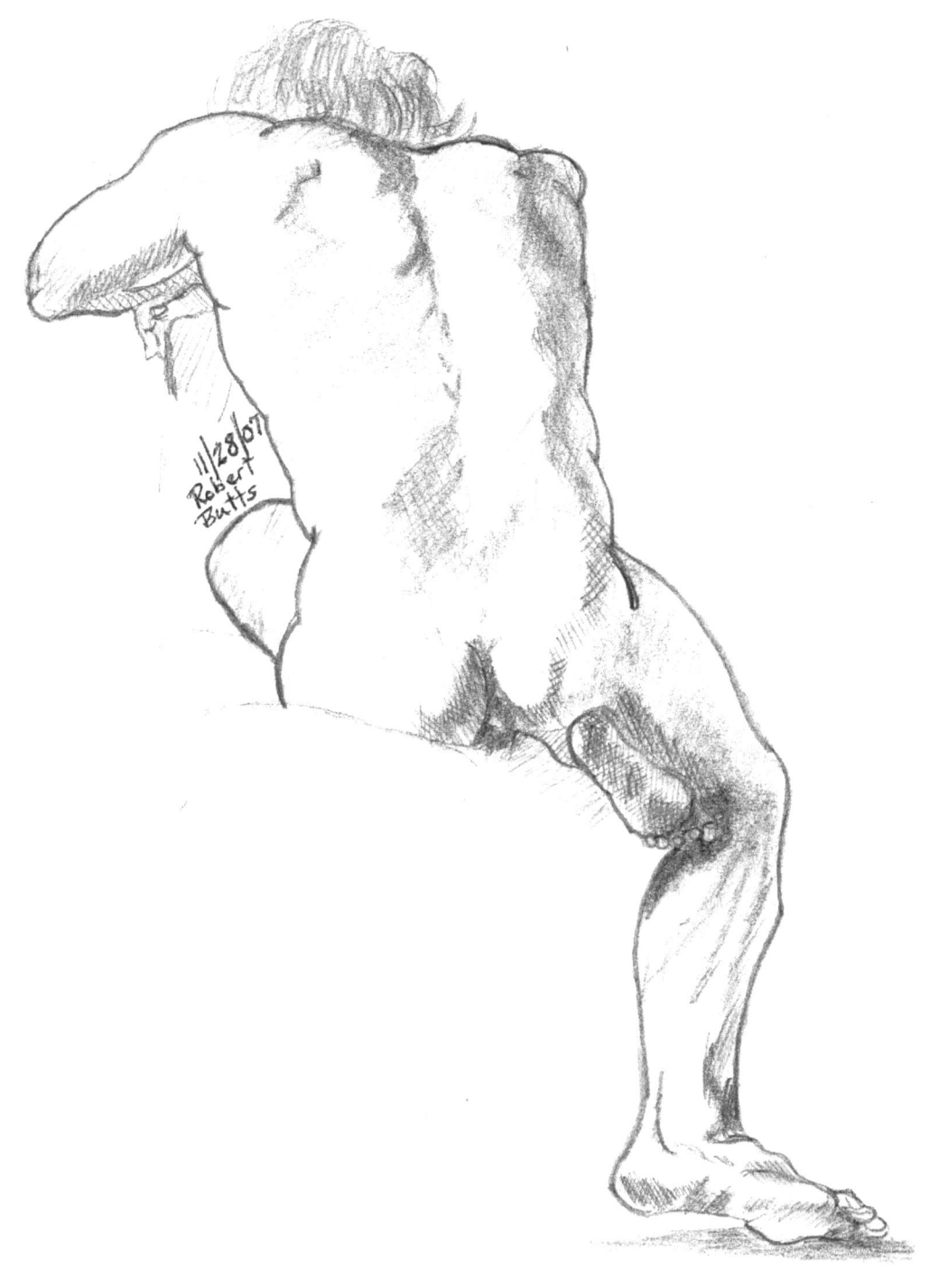

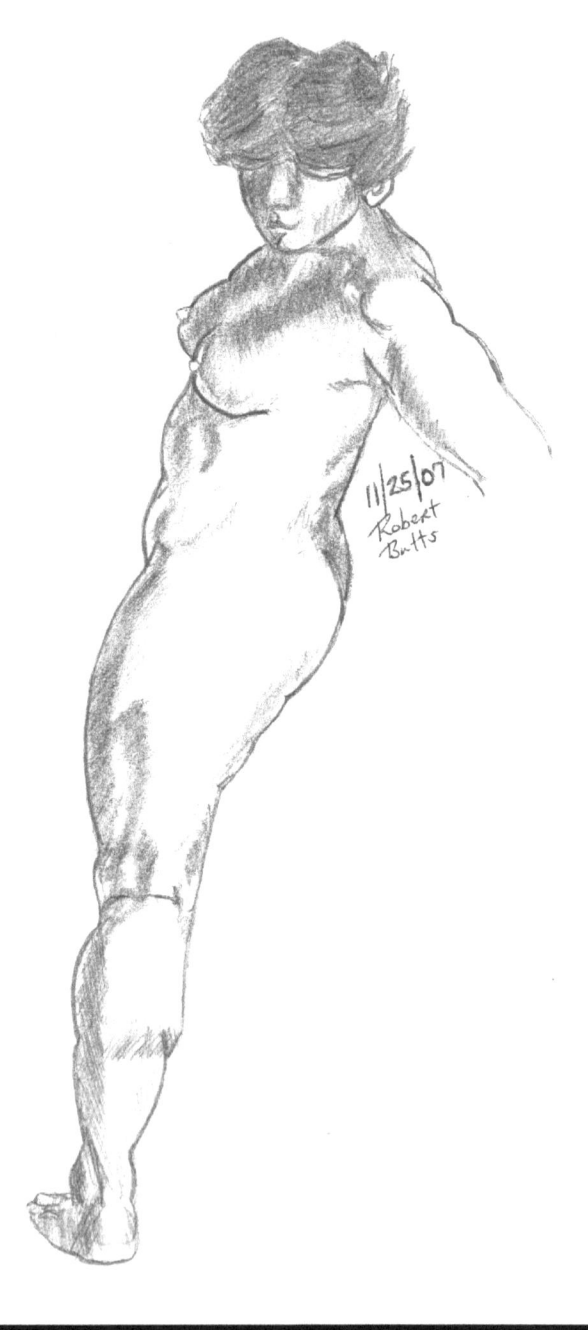

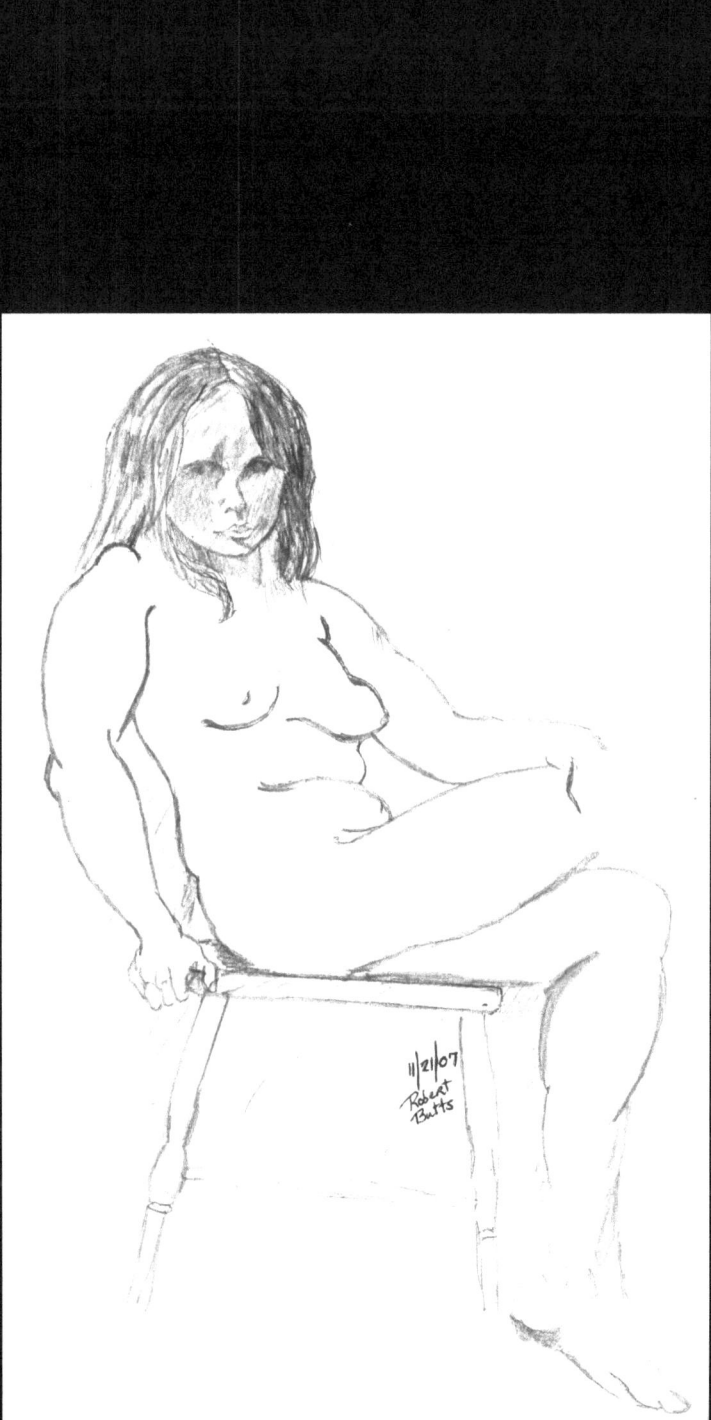

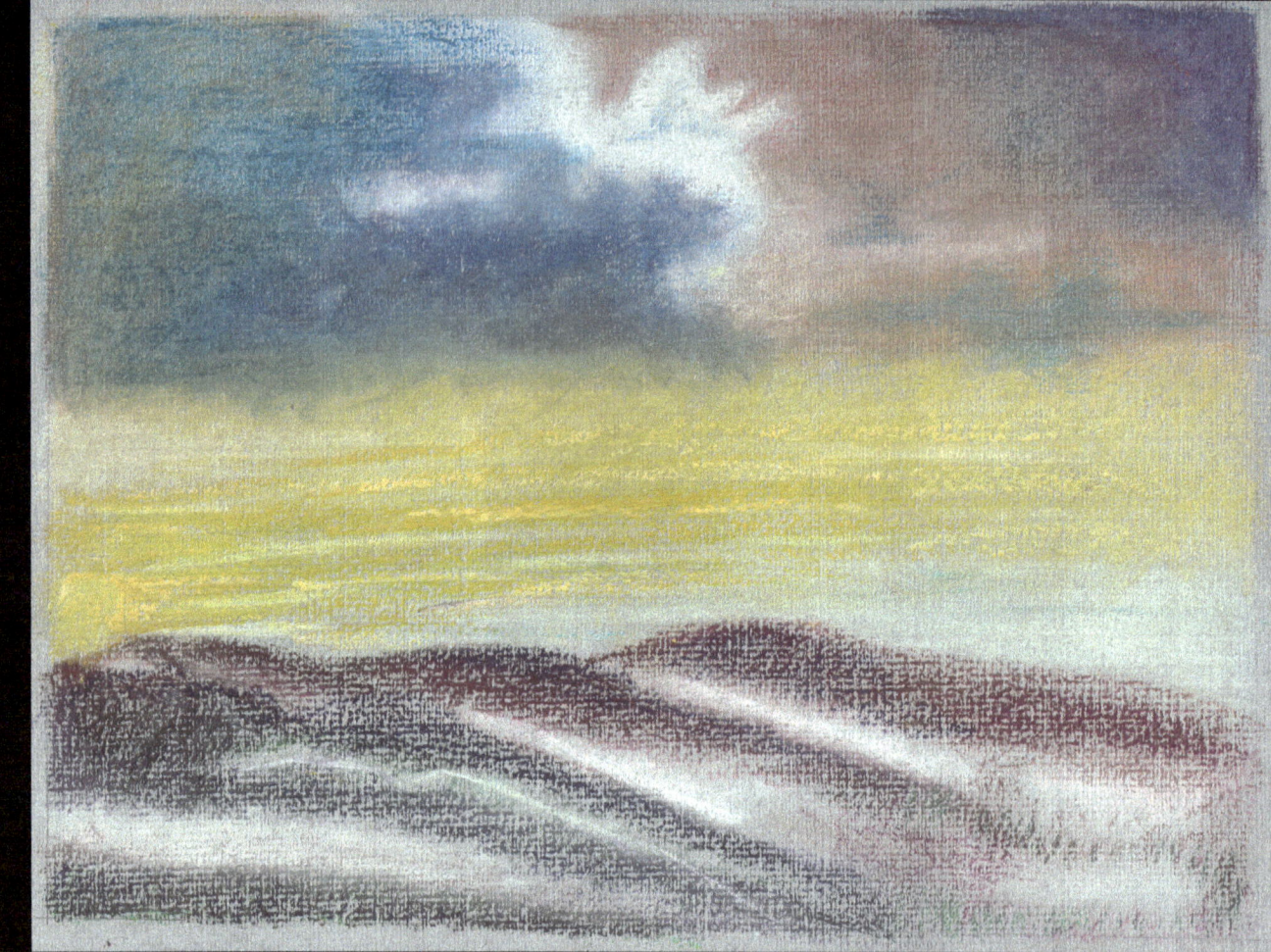

Nature on My Mind

Even as a little kid, I always had a love for the outdoors. I grew up in the city, and played football and basketball with the older kids. I went fishing with adults whenever I could, and was eventually entered into a fishing tournament. When I got my first air gun, I tried to do some hunting but there was nowhere to practice, and people would sometimes call the police if they saw any kind of gun.

We moved to the country when I was in the sixth grade. and I dreaded the move because I was leaving all of my friends behind. I soon began to embrace my new home, however, when I discovered a fascination with nature. Immediately I wanted a pet, but received no signs of relief from my guardians, so I learned early on how to improvise. I remember capturing caterpillars and keeping them in a jar, feeding them grass until their metamorphosis was complete, then releasing them to fly away and be free. In addition to the caterpillars, I caught frogs and turtles.

I remember taking a baby bird from a nest. I didn't initially want to do this. The nest was in a tree in our front yard. I wanted to watch the mother raise her young, but my brothers kept interfering with our guests until the mother finally started to move the family. I heard my brothers talking about it, so I went to see for myself. When I looked in the nest, I only saw one of the three left from the litter. That's when I made the decision to capture it.

I made a nest of out of hay placed in a shoebox, put my new friend in it, and carried it to the house. We named this bird Joey, and Joey became so comfortable with us that he'd hop out of the shoe-box and come looking for us when he wanted some more bread and water. All we had to do was stick a finger out and hold it close to him and he would jump on the finger so that we could carry him around.

One of my favorite cartoons at the time was "The Seahawks," a cartoon in which birds would team up with super-heroes to help catch bad guys. I was so excited about the prospects that I couldn't wait 'til Joey grew up to see if he would fly away and then come back to me. But that was not to be. One day, many birds gathered to feast on a berry bush in our backyard, and we figured that Joey would like some berries, too. We didn't know much about raising birds. Joey died at that happy feast. I had other opportunities to catch baby birds, but watched them from afar instead. I had learned my lesson.

Before my encounter with Joey, birds were my primary targets of prey because I only had a pellet gun. The adults used to tell me not to kill them unless I planned to eat them. I understood what they were saying in theory, but it wasn't until after my encounter with Joey that my eyes began to open to this in practice.

One afternoon while walking with my cousin through the woods on a hunting expedition, we unexpectedly encountered a deer. We were practically on top of the deer by the time we saw it. My cousin took off like a bolt of lightning, the deer leaped and took off, and I sped away after my cousin. I couldn't convince my cousin to do much more hunting with me after that, so I soon began taking long walks through the woods alone. I didn't always go to hunt -

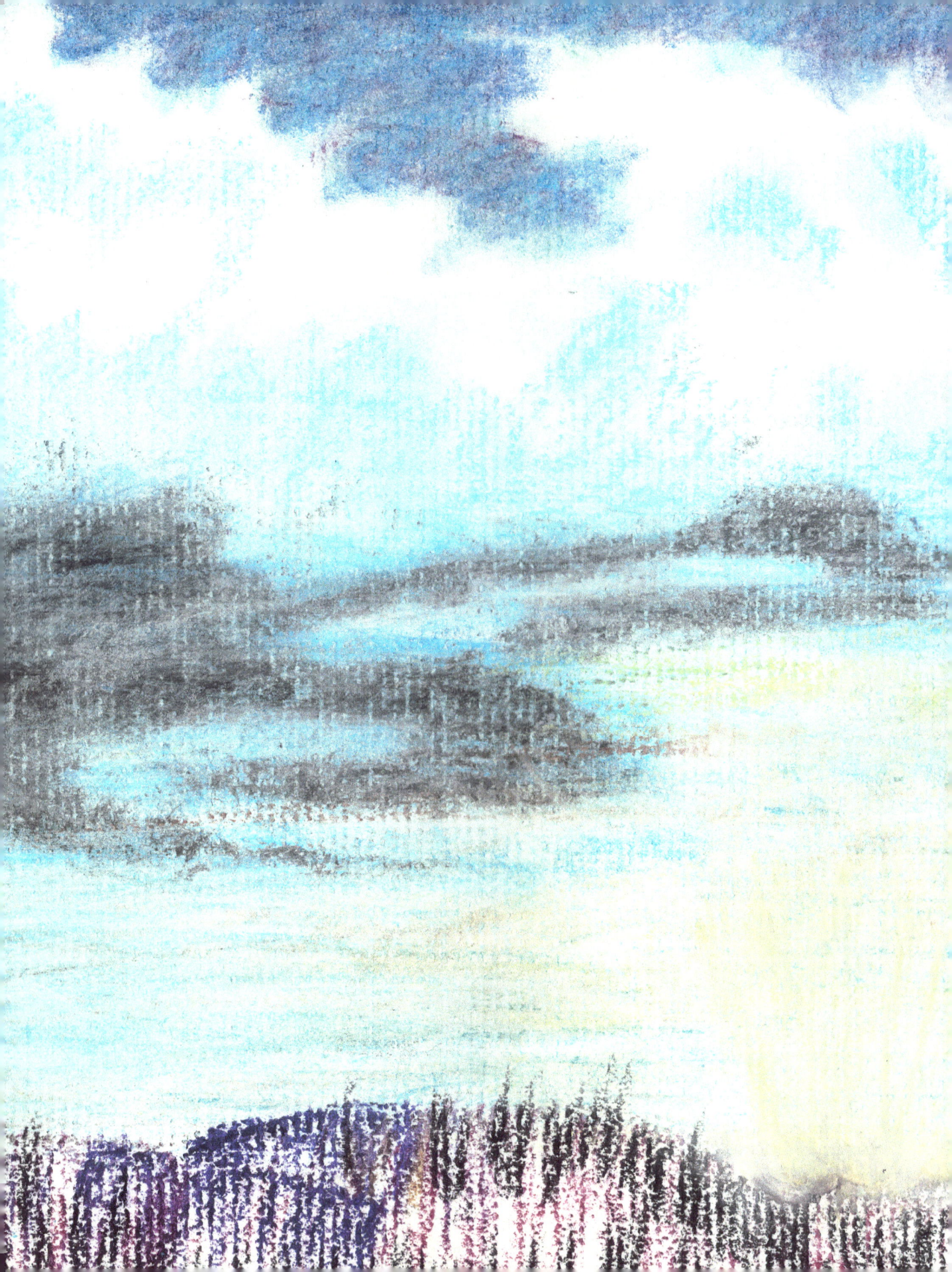

sometimes I merely wanted to be surrounded by the amazing scenery.

One day, while witnessing physical abuse done to my mother by her boyfriend, I grabbed my pellet gun and considered shooting the perpetrator to stop the physical abuse, but instead I went to my cousin's house to call for help. Afterward, not anxious to go back home, I took a detour and strolled through the woods. My feelings were hurt by how quickly all the creatures ran for cover. Although I had my gun, I had come in peace, but they had no way of knowing this. I sat next to a tree on the side of the pathway, and let my thoughts run freely through my mind: about how things would be when I went back home, about not going back home, about the few options that were available to me.

After a while I realized that the animals were beginning to resurface from hiding. I saw a squirrel in the trees. I heard something in the bushes, perhaps a rabbit, but what surprised me was when a bird landed right in front of me across the path. I had a clear shot. I considered taking my anguish out on this bird, but I didn't want to scare off the animals again and be left alone. Besides, this bird was similar to Joey. At that moment, I thought about Joey and I began to understand in theory and practice.

Over time, I made many more trips down this pathway, but not to hunt. This became a place where I could clear my head of troubles and be at peace. These woods, and the animals that lived here, were no longer my enemies. I became their guest, and it was almost as if we became friends, judging by the way we coexisted.

One night after arguing with my mother, I stormed out of the house. Soon realizing that my options were few, I decided to walk the pathway, calm down, and think. There was a full moon, so bright and crisp that there were actually beams of moonlight coming through the trees. I stopped for a while and leaned against a tree. Suddenly, a huge shadow walked toward me, menacing yet strangely reassuring. It was a deer and we shared a beautiful moment together, just looking at each other in the heavy frost.

I left home because I wanted to get out and be alone. Thinking back upon these times, I can see clearly the incredible blessing that is one's freedom - to be able to just get up and leave a situation in search of a better one. The pain that its loss can bring to a person in my situation is indescribable, yet very persistent.

I once had a bad dream consisting of a series of events concerning my grandmother. There was a time when we argued and it made her really mad when I wouldn't listen to her, so mad that she took me home at 7 a.m. that same morning. In this dream the argument merged with my hearing the news that she had suffered a stroke and was in a coma, on life support, with my family beside her. I woke up and, while still half asleep, got up and put my shoes on with the intent of going to the hospital. When I got to the door of my room, I couldn't open it. I looked at the door a bit closer and saw bars. I looked around me and saw cement. I began to awaken mentally and reality dawned on me. I walked back to my bunk and sat there for the rest of the night.

It's amazing how you can tie all the moments of your life together and make them fit cohesively. I look out at the sky and see that this part of the day would be a nice time to walk the forest pathway. The animals are probably there living their lives, enjoying themselves, and having fun. If there is one thing I wish I had taken away from watching those animals partake of their daily rituals, it would be how they enjoyed and maximized their freedom.

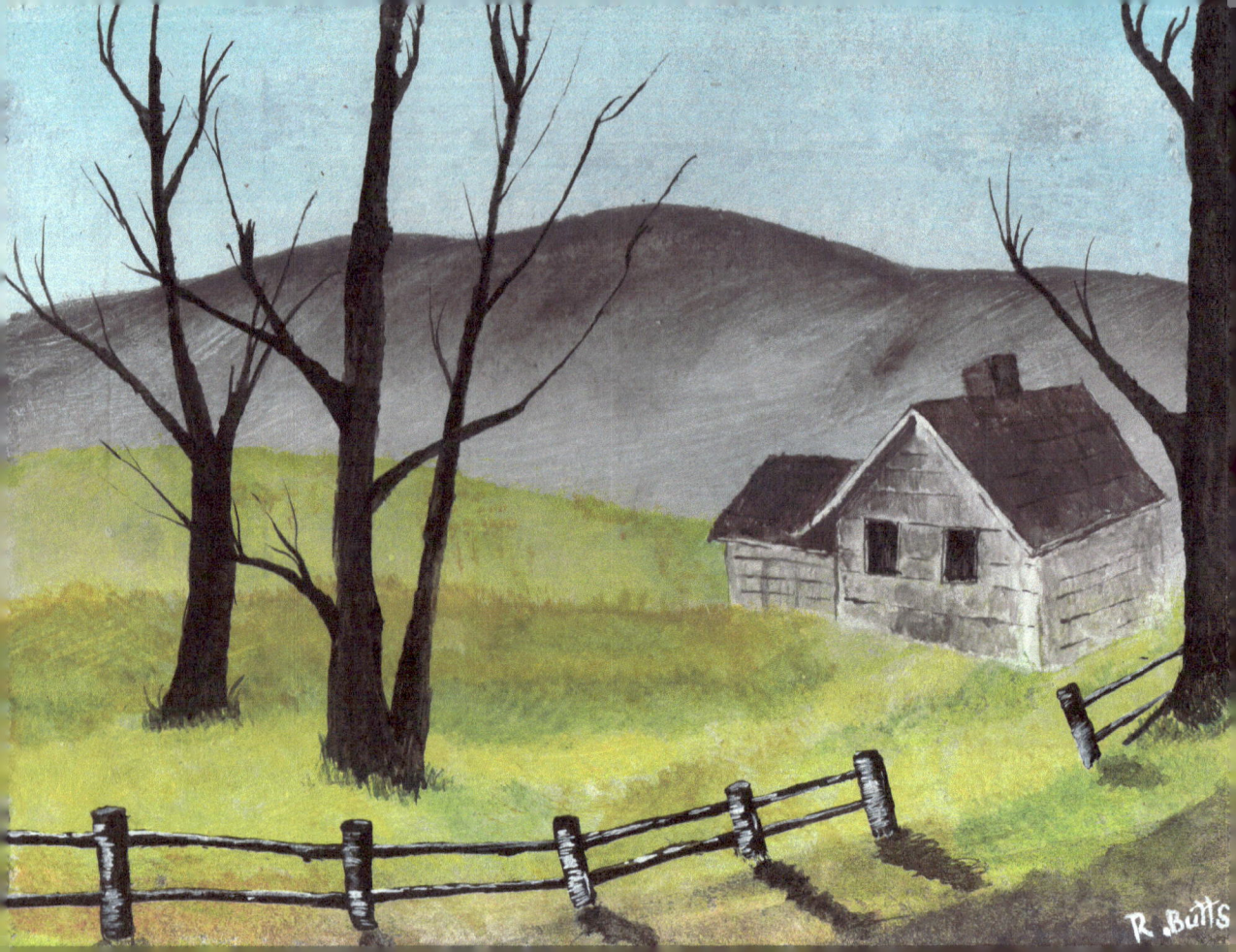

All of the paintings in this book were created with paints hand made from floor wax. Robert extracts pigments from coffee, taco sauce, dyes from brightly colored postcards, book covers and other materials.

An Eternal Connection

dedicated to my grandmother, Mrs. Mary Cooper

I've never been good with words,
When expressing my true love
for you…
And I've had plenty of chances…
I~
I just didn't follow through.
Maybe,
I could've done more.
But…
That's why I'm here now.
I want to undo
All the wrong I've done
but…
I just don't know how.
So,
I look to you for guidance.
The same
As I would a compass…
Because you are intelligent.
Have taught me many things
that…
I thought were irrelevant.
Now I understand,
my vision is clear.
It reminds me of your presence…
That your spirit is near…
I'm just doing my part.
Paying my respect,
While holding
Your memories down…
I just want you to know,
that I know…
Your spirit
is still around.

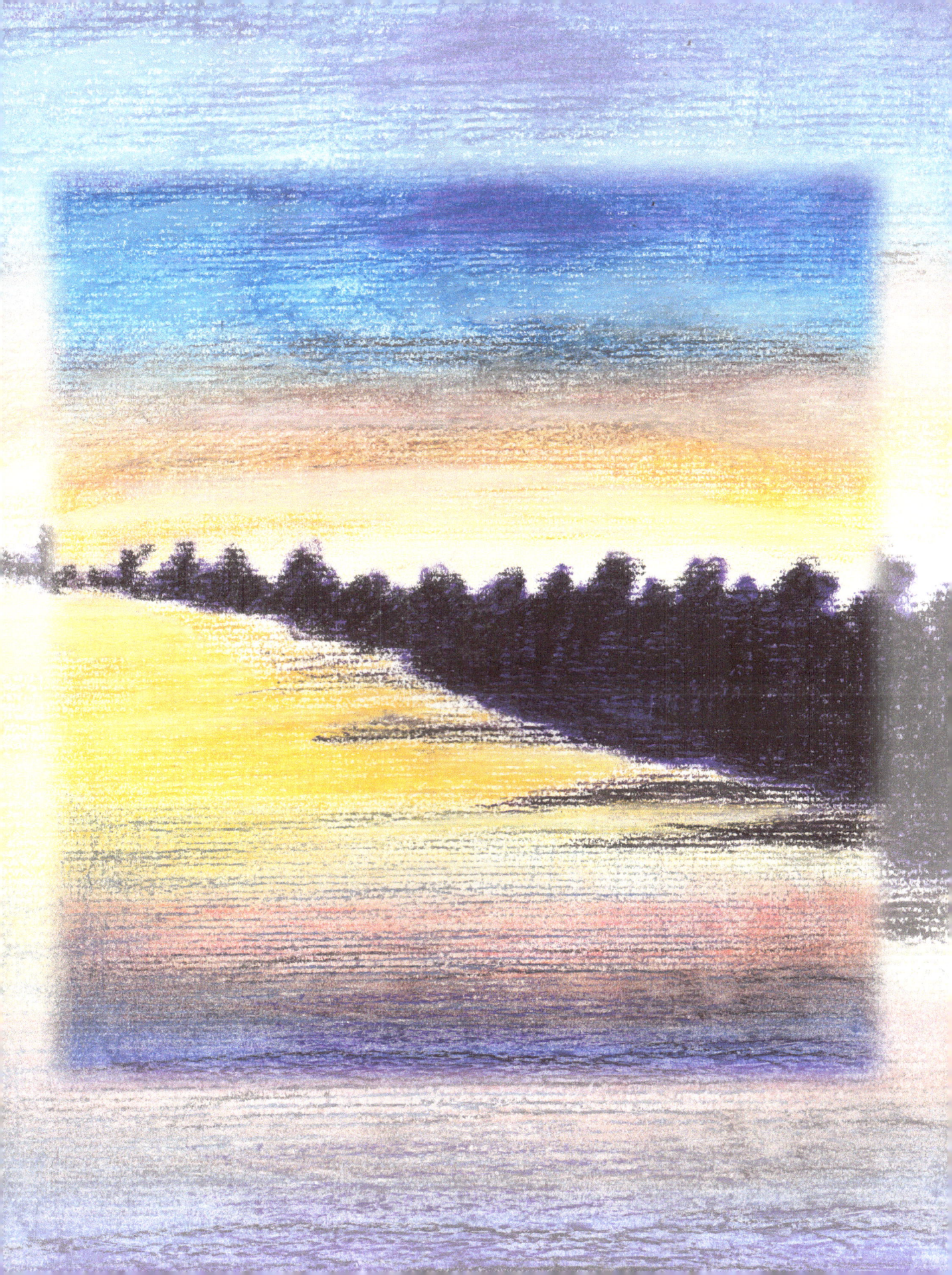

Unspoken Love

Dedicated to the late Bobby Waller

It is like we never met…
and hardly even spoke.
We allowed time to pass us by…
when we could have wrote.

We grew more distant
with each passing year.
And although we never bonded…
mutual love was always near.

If I could turn back…
the crooked hands of time.
I would write you a decent letter…
reflecting what is on my mind.

In remembrance your name shall live…
just as your caring touch.
Through our love you shall live on…
we appreciate you very much.

These words are merely meant…
to express love for you.
In my heart you will remain…
the uncle I wish I knew.

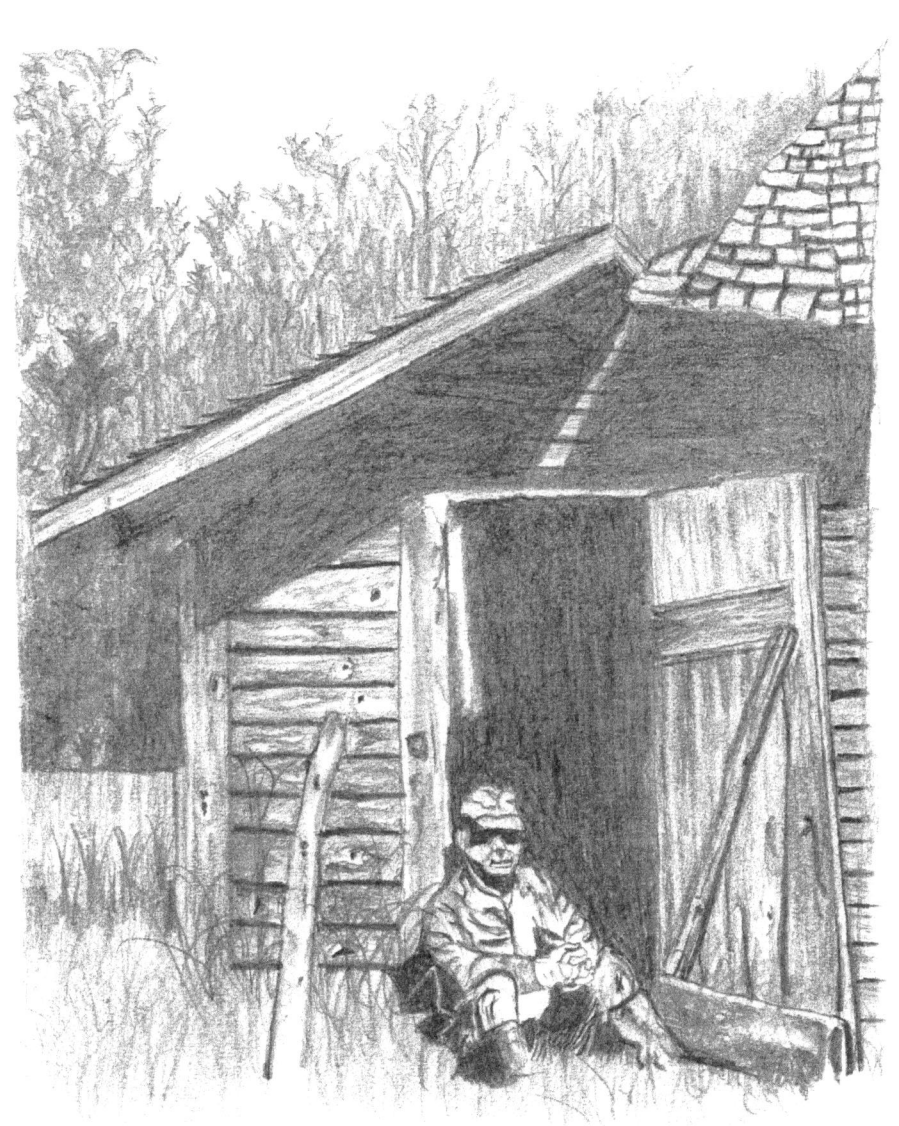

Mixed Feelings

Your mind
is tortured
burning in
flames.
Picture this...
Your mind
is tortured
burning in
flames.
Your desires
are weaken,
thoughts filled
with shame.
No game.
It's real,
and hope
is hopeless.
No where
to turn.
No love.
No focus.
It's dark,
No light.
No stars
in the sky.

It hurts,
there's pain
No tears, can't cry.
No lie!
It's real,
to survive
takes skill.
Stay strong.
Rebuild.
And learn
how to live.
No room
for error.
Escaping
this terror,
No quit.
No surrender.
Never
say never.
When your mind
is tortured
burning in flames.
Close your eyes
look inside.
Have faith,
maintain.

This account was written by Robert's attorney as related by Robert.

Robert's life parallels that of too many youths emerging from today's urban communities, encountering violence and economic lack at an early age, and living hard, fast lives until ending up dead or, as in Robert's case, incarcerated, before reaching adulthood.

Born in Milledgeville, Georgia, a small city lacking in opportunities for the local adolescents to use their energy and exuberance in positive and productive ways. Robert grew up in Milledgeville, despite a keen interest in travel and foreign places, until he was incarcerated at the age of 17. In fact, Robert has never left the state of Georgia due to a series of tragic events that occurred at an early age in his life.

Before Robert was old enough to remember him being there at all, Robert's father left home. He has no picture of his father and, if he saw him today, there's a very good chance that Robert wouldn't recognize him. Robert grew up in the presence of step fathers who did not make the effort to get to know him or provide him with positive role models. Robert ran away twice after abusive encounters within his household.

In addition to the violence and alienation, Robert's early life was shaped by economic poverty. Robert didn't have enough sets of clothes to get him through a normal school week. There were times when he had to wear shoes with holes in them to school. Robert was, and still is, a very bright young man and was an honor role student for most of his school years. Given the financial situation of his family, Robert went to work as soon as he was able. In the 10th grade, he started working part time and stopped applying himself to his schoolwork and subsequently dropped out of school a year later.

Sacrificing his education in order to work seemed like a good idea at the time, but Robert was not prepared for the demands of the adult working world. After leaving school, Robert discovered the full time working class to be intolerant of teenagers and their immature ways, and he soon lost his job. Before long he was hanging with other dropouts and misfits trying to hustle and make ends meet. He wasn't ready for what he found in that world, either.

In the spring of 1996 Robert decided to get away from the street life and go back to school; however, on the way to visit his grandmother one evening he got caught up with the old crowd, was arrested and never got his chance.

Robert has two brothers and two sisters; he is the second oldest. He has an older sister who is currently in the Air Force and is stationed in Germany. His youngest sister is scheduled to graduate this year. None of the brothers, however, made it through high school. Unfortunately, Robert doesn't share a close relationship with any of his siblings, and although he wishes things were different, he knows this was not the way they related to each other while growing up, and he has come to accept it for what it is… silent love.

Robert was adamant that I state that he makes no excuse for mistakes he has made during the course of his life. He believes there are reasons for everything. Just as there is a reason he dropped out of school, there is a reason that he is on death row.

My Life
Part II

A life which lacked guidance,

such a supple soul…

Weighed down by pressure,

but yet it would not fold…

A life that fought restraint,

not to drown in this world…

Pressure increased upon this soul,

until it finally began to curl…

A life with a broken spirit,

and no where to turn…

Torched by a continuous force,

thus left alone to burn…

A life that has survived,

the essence of defeat…

Through the legs of a soulja,

Stand again on his feet…

A life that refused to lose,

such a supple soul…

At times he may bend,

but never will he fold…

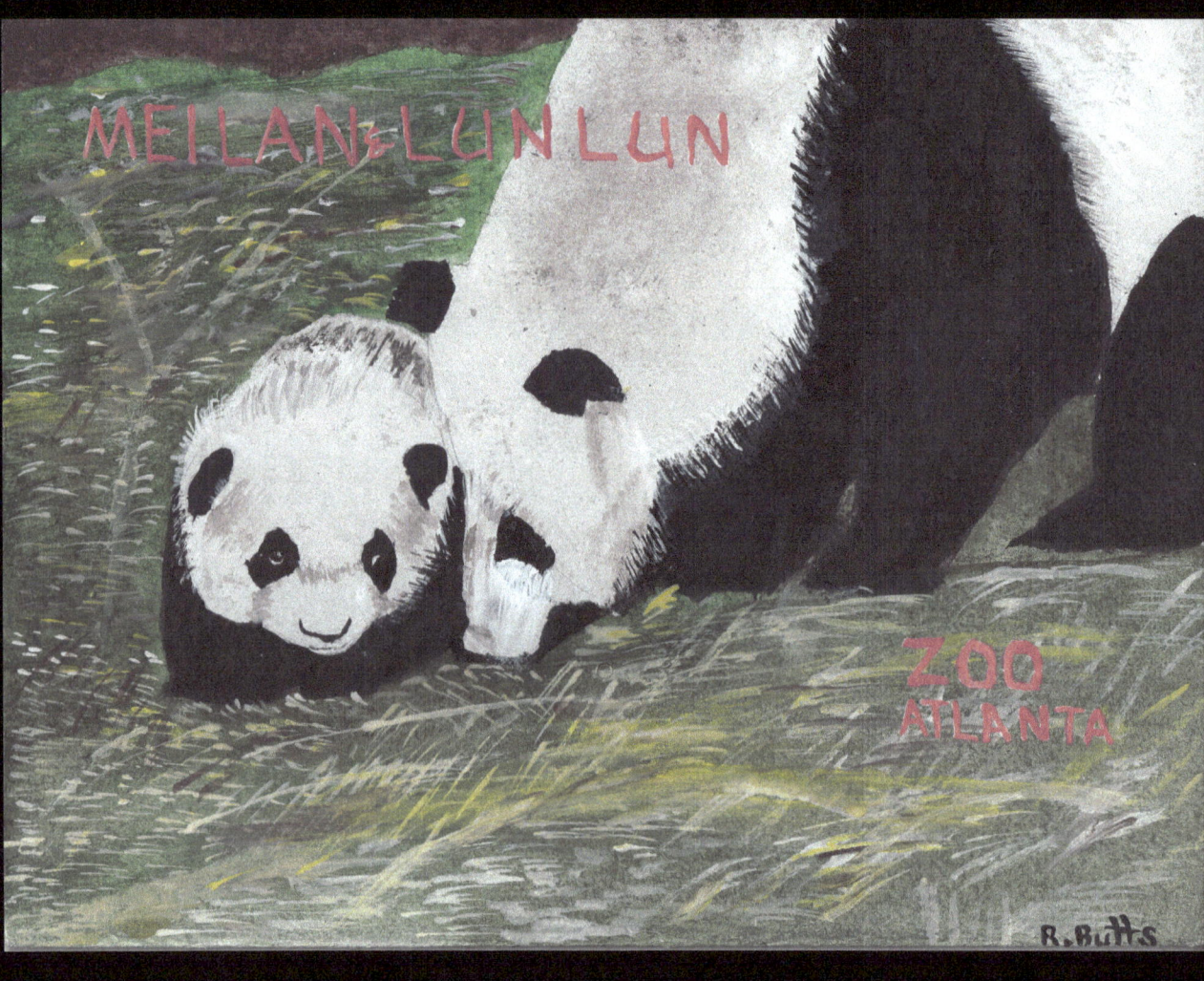

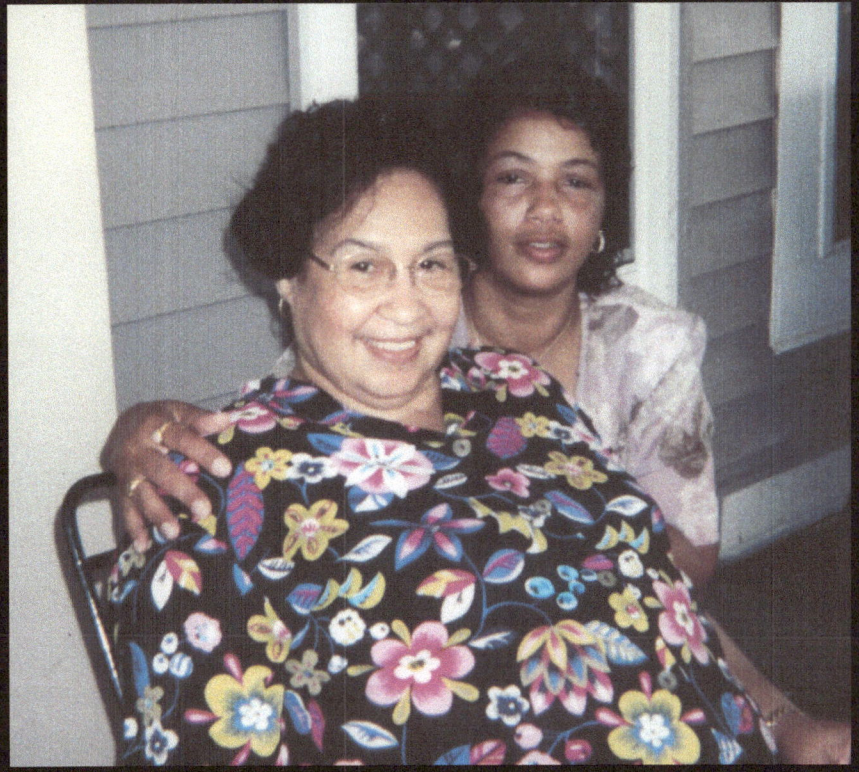

Mary Cooper and Laura Butts
Robert's grandmother and mother

Mother's Day

A very honorable day,
with such a beautiful theme.
Yesterday you were a princess,
Today you are a queen.

Always there for me,
Never absent at my side.
The keeper of my secrets,
the diary in which I confide.

Cherish and protect,
is how you love me.
Especially when I was growing up,
And needed your eyes to see.

Everyday is Mother's Day,
Your love is always near.
As long as I have your love

There is nothing that I fear.

A very honorable day,
with such a beautiful theme.

Yesterday you were a princess,
Today you are a queen.

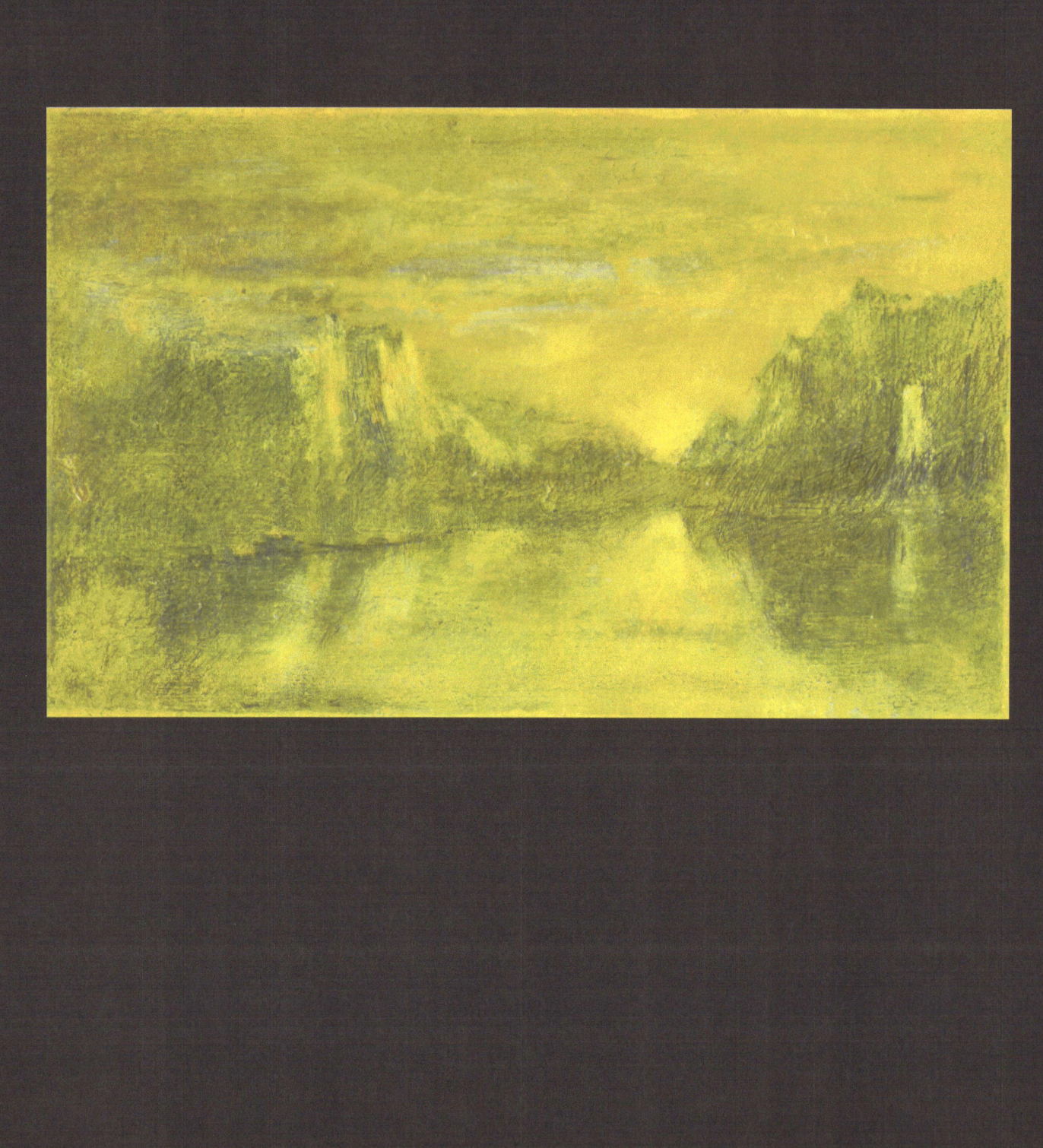

Now and Then

Sometimes I can be foolish,
In my own way.
But don't get it twisted,
Listen to what I have to say…

Sometimes I can be absurd,
This is very rare.
Because nine times out of ten,
My actions are usually fair…

Sometimes I am passionate,
This is mostly me.
I tend to adapt at times,
To whatever I'm needed to be…

Sometimes I get angry,
And understandably so.
I'm caged up like an animal,
And need more room to grow…

Sometimes I can be charming,
When my heart is amused.
I'm still a lovable person,
So don't get it confused…

Sometimes I get lonely,
And my heart longs to be touched.
I tend to get a few letters,
But they can only do so much…

Sometimes I tend to change,
We all do at times.
The only difference is,
I can admit to mine…

Sometimes I wanna cry
But can shed no tears.
I guess I lost them all,
Over the course of my years…

Sometimes I have dreams,
That I'm out there with you.
We spend the whole day together,
And talk the night through…

Sometimes I wonder how,
I wonder why…
That in the end I'm left alone,
With me, myself, and I…

Back In The Day

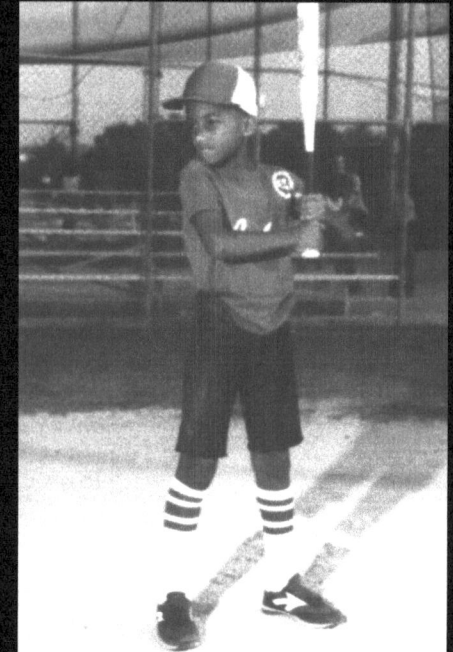

I remember way back when,
As just a little kid…
To avoid getting a whipping,
I took the belt and hid…

What about the time
When I fell off my bike…
I kept getting back on,
Until I finally got it right…

Did you have a moment
When determined to climb a tree…
But kept sliding back down,
And scraped up your knee…

What about the time,
When you got your first pet…
A happy lil' shorty
A moment you'll never forget…

There were also times
When we snuck to the store…
Got caught stealing,
And still went back for more…

Then we grew on up,
To become teenagers…
Back during these days,
There were no 2-way pagers…

But we did have beepers
Trying to flex on the block…
Chillin' like a playa,
That worked around the clock…

Remember back in high school,
when we used to skip class…
Missed out on studying,
And had to cheat to pass…

Did you ever have a fight?
Of course I had a few…
I was far from a bully,
But I fought when I had to…

Some left before others,
But we all parted ways…
Many friendships ended,
So did my carefree days…

The Joy of Freedom

The life I once knew,
was filled with this joy.
It should not be taken for granted,
thus, it is no kind of toy.

How can I rejoice again,
constantly plotting on the wayz.
Realizing this beast is a sturdy one,
and numbered are my dayz.

Stuck in the belly of the beast,
and darkness is all I see.
Standing in liberty once again,
is all that I strive to be.

It is all that I strive to be,
all that I want to know.
It must be abundant to all who seek,
the nourishment needed to grow.

I have finally solved the mystery,
that has escaped me all these years...
Cherish all that you value in life,
or live accustomed to tears.

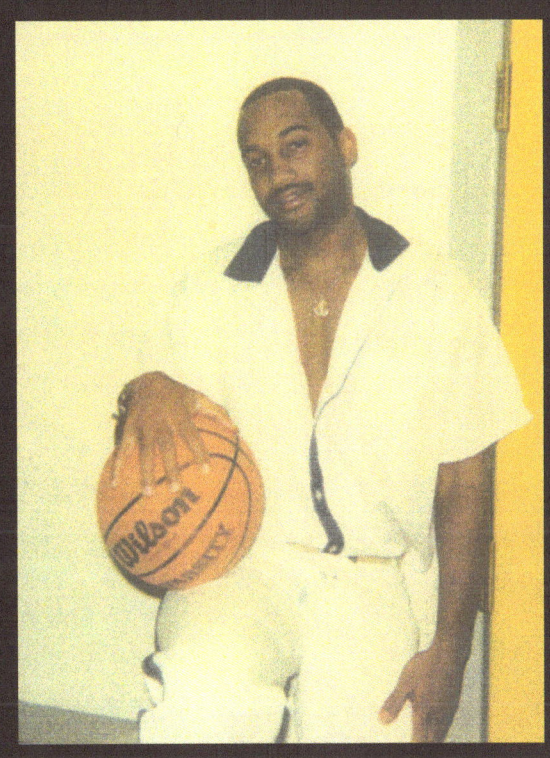

Dream On

I once had a dream…
That the world was at peace.
All the wars ended,
racism came to a cease.
The homeless people were sheltered,
with a comfortable place to sleep.
They all found decent jobs,
were able to stand on their feet.
The starving people were fed,
very well indeed.
They also had this opportunity,
to stand proudly and succeed.
Then there was a stunner,
as I envisioned death row.
The court system actually worked,
and innocent men were let go.
We fought for redemption,
even without amends.
Because everyone makes mistakes,
and this message we were to send.
I cherish this opportunity…
To share with you my dream.
Because we will perish until we realize,
We're all on the same team.

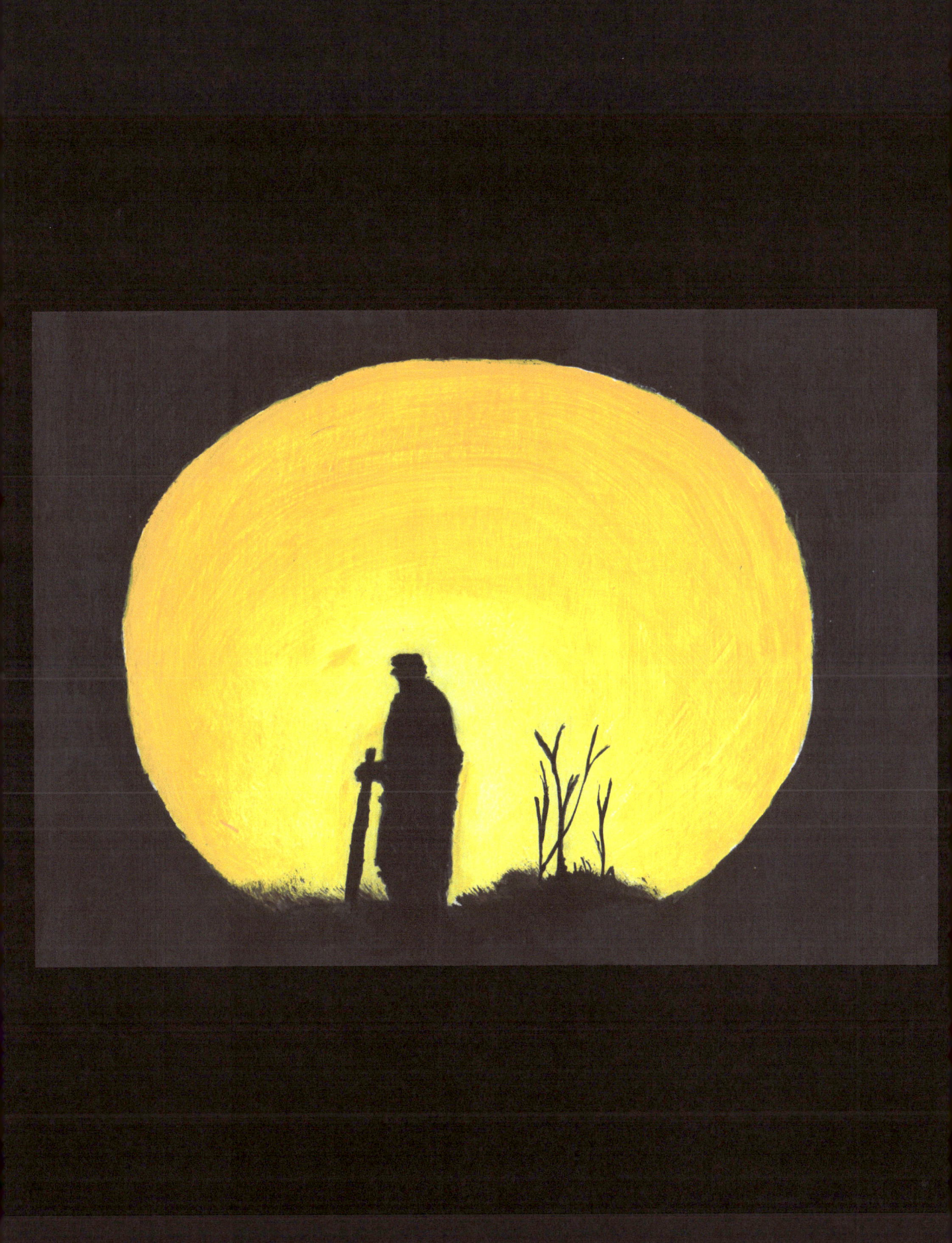

Original artwork and poetry by
Robert E. Butts

Book design by
Briar Rose Center
Saint Augustine, Florida
www.briarrosecenter.org

www.ingramcontent.com/pod-product-compliance
Lightning Source LLC
Chambersburg PA
CBHW051100180526
45172CB00002B/714